# GUYS & DOGS

photographs by
*Laurie Schneider*

# GUYS & DOGS

edited by
*Ruth Berman*

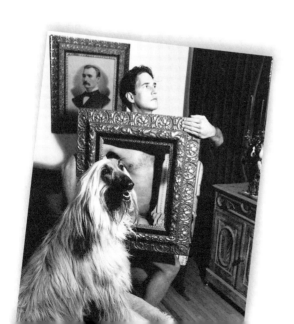

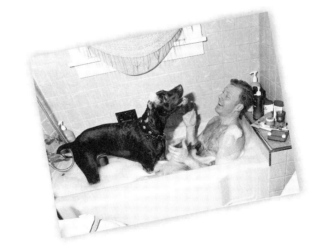

**BOWTIE**™
P R E S S
Irvine, California

DEDICATION *In honor of my mom and dad, Mary Ann and Christian Schneider, who trusted me to seek out my own path and instilled in me a great respect for the natural world and all her creatures.*

ACKNOWLEDGMENTS *I would like to acknowledge my life partner, Mike Rivard, for his thoughtful critiques and far-out ideas; Ruth Berman, editor-in-chief, for respecting my work and giving me this opportunity; and the men within these pages, for giving freely of their time to be photographed and for their respect and love for their dogs.*

—*LAURIE SCHNEIDER*

Ruth Berman, editor-in-chief
Nick Clemente, special consultant
Amy Fox, editor

Jacket and book design copyright © 1999 by Michele Lanci-Altomare

Text copyright © 1999 by BowTie Press
Photographs copyright © 1999 by Laurie Schneider

**Library of Congress Cataloging-in-Publication Data**

Schneider, Laurie, 1961-
    Guys and dogs / photographs by Laurie Schneider ; edited by Ruth
Berman.
        p.    cm.
    ISBN 1-889540-45-5 (hardcover : alk.  paper)
    1.  Dogs  Pictorial  works.   2. Dog owners   Pictorial works.  3. Dogs
Anecdotes.    4. Human - animal  realtionships.    I. Berman, Ruth.
II. Title.
SF430.S35 1999
636.7'0022'2--dc21                                                          99-37646
                                                                                 CIP

BowTie™ Press
A Division of Fancy Publications
3 Burroughs
Irvine, California 92618

Manufactured in the United States of America
First Printing October 1999
10 9 8 7 6 5 4 3 2 1

# Introduction

Our world is full of doing this and rushing there and not enough time and *I'm so busy* and stresses. We've built cities, pouring concrete all around us like a protective shield, keeping the conveniences of modernization in and nature out, except in dribbles here and there where it suits us. But from the time we've lived in caves, one of the constants has been our ongoing relationship with the dog. With the dog, we're allowing a little bit of nature into our homes.

One would think that the responsibility of a dog would only add to the hustle and bustle of our lives. But it doesn't seem to. All the guys in this book filled out a survey, and although one or two of them mentioned the time that their pets require, these statements were followed by how much the dogs give back. Personal trainer, friend, child, partner, peacemaker, comedian, psychiatrist, these all are words guys use to describe their relationships with their dogs and the roles dogs play in their lives.

You may not find out within these pages why guys and dogs share such a special bond, but you'll certainly find out what it is that guys get from their relationships with their dogs that has made the phrase *man's best friend* synonymous with *dog*. The emotional support, companionship, and humor that dogs have added to these guys' lives is unmistakable. Laurie Schneider's special talent for capturing this bond with black-and-white photography illuminates each unique relationship between the guys and their dogs.

Become a part of this book by creating a profile of you and your dog or your favorite guy and dog couple at the end of the book. Write your thoughts about the special dog in your life and paste in your favorite picture.

One message we can take away from *Guys & Dogs* is that dogs put a bit of nature back into our concrete-filled, busy lives, slowing us down enough to make sure we enjoy each day.

*Ruth Berman*

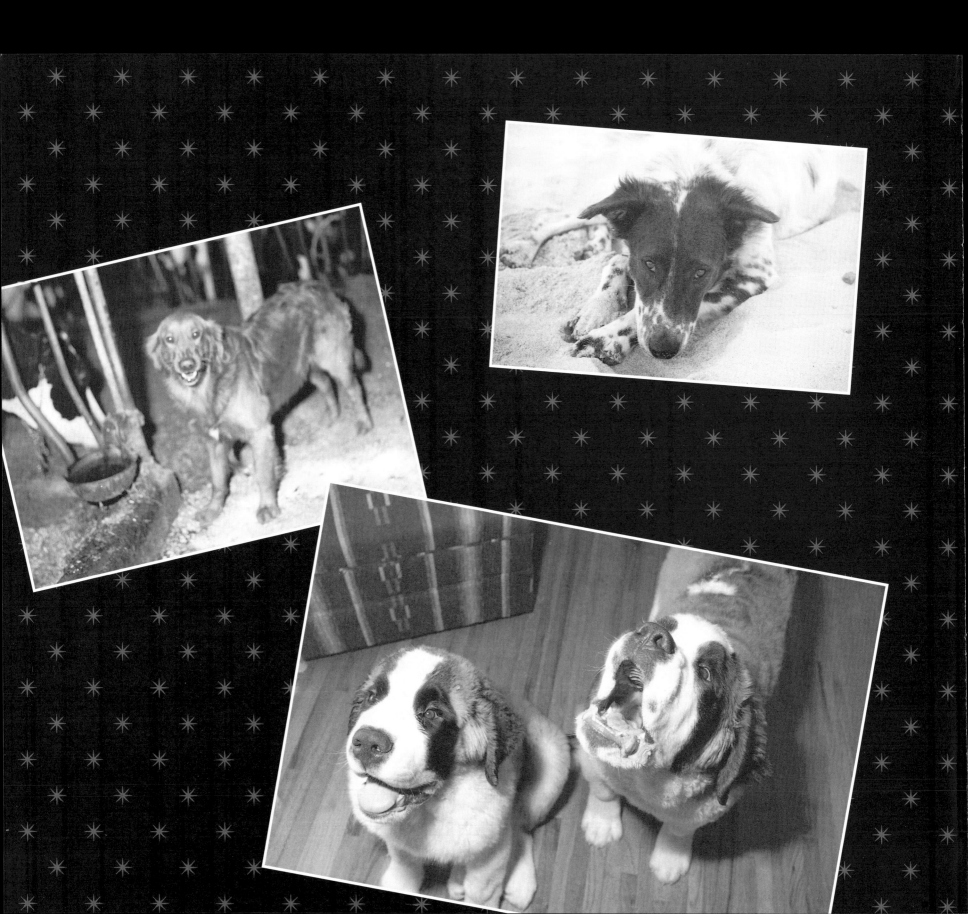

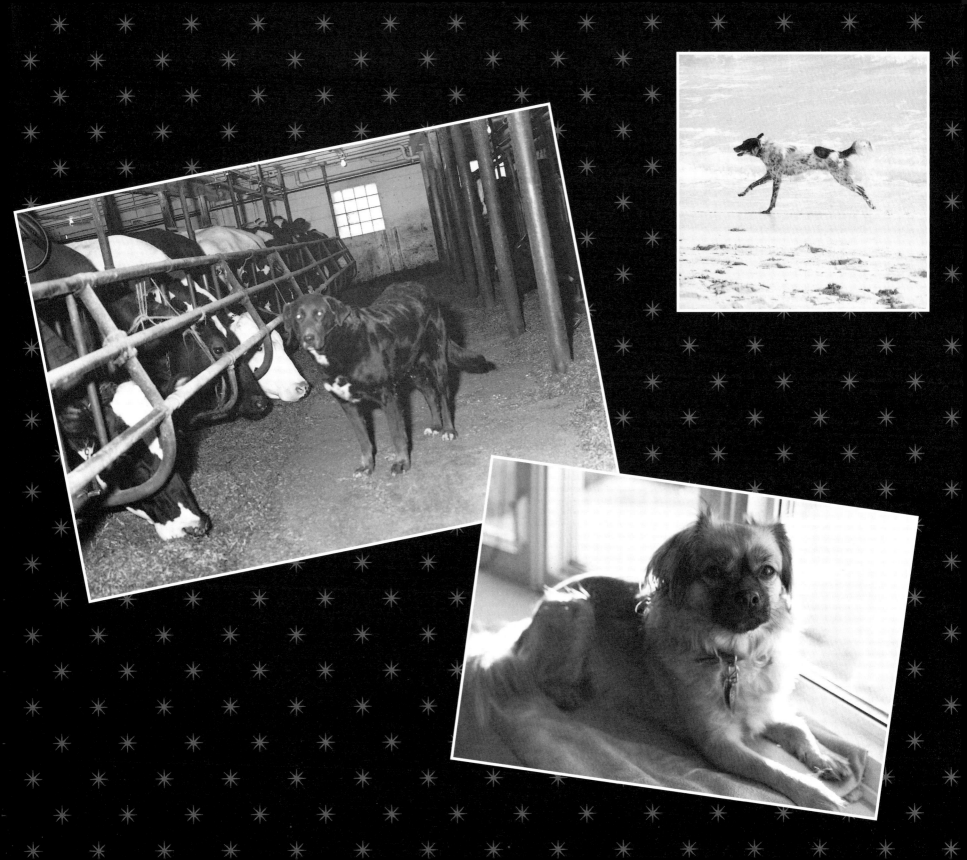

# PAUL & JUSTIN GABBERT

Buck — Retriever

DAIRY FARMERS
50 & 24 YEARS OLD
MARRIED & SINGLE

Woody — Shepherd

*These dogs are so faithful & forgiving—*

*It would be good if more people were like that.*

*Every dog has its own and different personality:*

*one's shy, one's a hunter, one's gun shy, one's very bold.*

Sam — Shepherd

*Flossy belonged to our neighbor, but he decided while walking*

*across our land one day that he wanted to stay here instead.*

*So he did.*

Flossy — Lab

Benji — Mix

Occupations: Farm and Guard Dogs

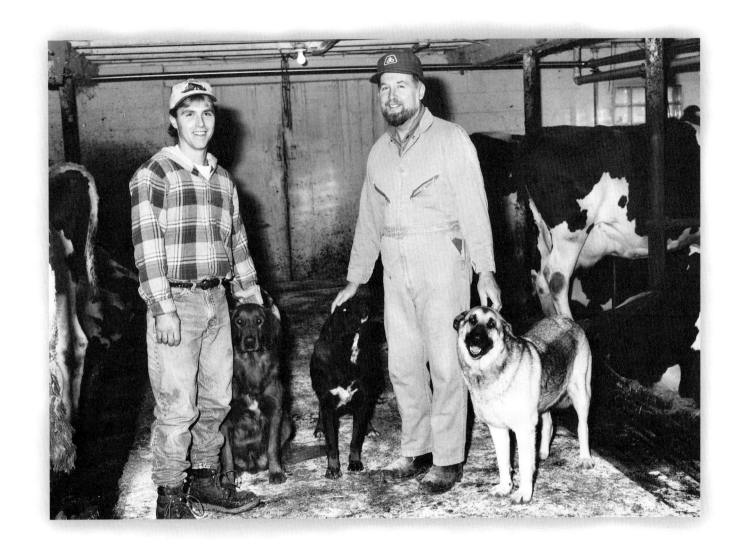

Recollect that the Almighty, who gave the dog to be companion of our pleasures and our toils, hath invested him with a nature noble and incapable of deceit.

—Sir Walter Scott

# STEVE SCHNEIDER

INSURANCE AGENT

35 YEARS OLD

MARRIED

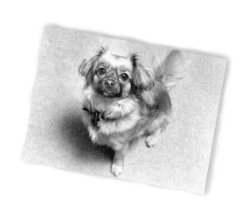

## Cajun

Pekingese Mix
3 Years Old
Occupation: Home Security

*My best golf buddy moved to Chicago and Cajun has more than taken his place. You can always depend on her—she never misses a tee time.*

*Cajun reminds me of Princess Di because she's beautiful and regal, caring and enduring.*

*Cajun has contributed to all my recent achievements because she helps to relax me and relieve my stress.*

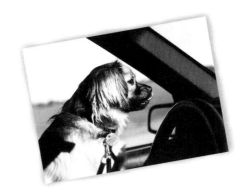

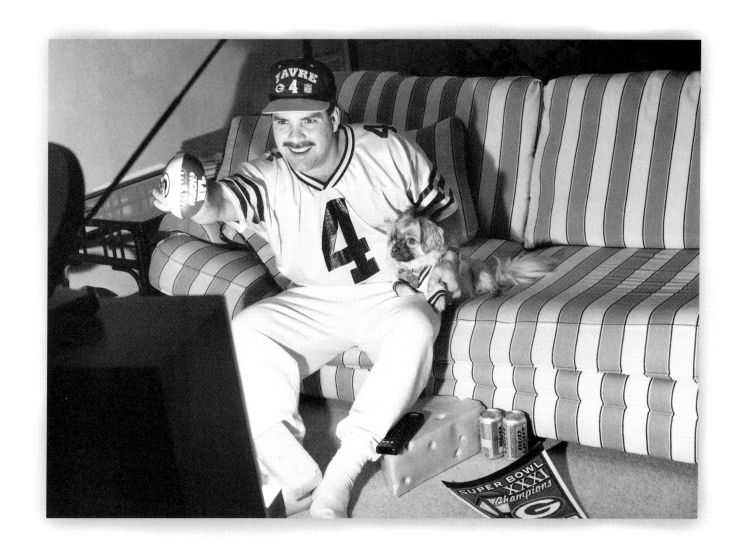

The average dog is a nicer person than the average person.

—ANDREW R. ROONEY

# MIKE RYAN

SINGER/SONGWRITER

SINGLE

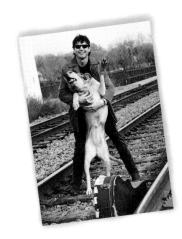

## Lucy

Labrador Retriever
4 Years Old
Occupation: Air Traffic Controller

*We were introduced by her mom who couldn't keep her anymore. She was eight months old and*

*knocked me out with her beauty, color, and shape. A week later it was her personality.*

*My dog is my roommate and my faithful companion. She's someone I can play with and look after.*

*She keeps me down to earth and reminds me of the simple things in life.*

*There's nothing quite like coming home to a twirling beast*

*ready to jump in your arms. Of course, she can get on*

*my nerves too, but it's all part of the charm.*

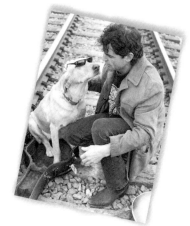

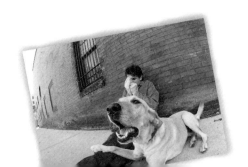

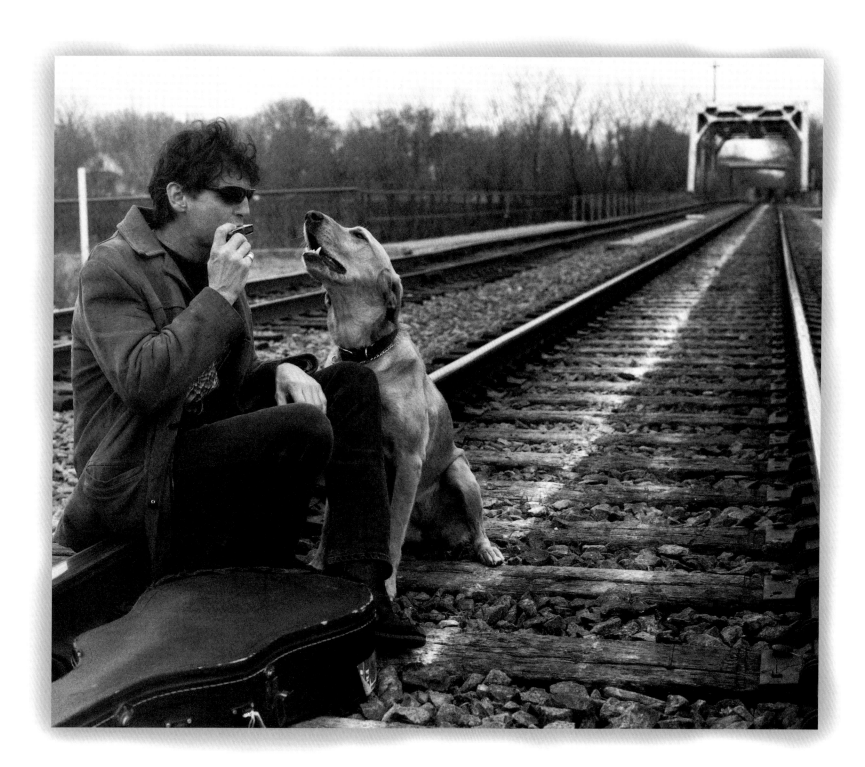

# TIM RIVARD

Inu

Japanese Chin
Occupation: Dog

STUDENT

SINGLE

*Inu was originally my grandmother's dog when she lived with my parents and me. He was around to keep my grandmother company. They really took care of each other. When my grandmother passed, she left Inu to me. There's no way Inu could replace her, but we share emotions daily. Without Inu, losing my grandmother would have been a lot more painful.*

*Inu has helped me through many hard times, losing family and friends. He always knows when things are wrong, and he knows what to do to help—cuddle, play, be alone, whatever.*

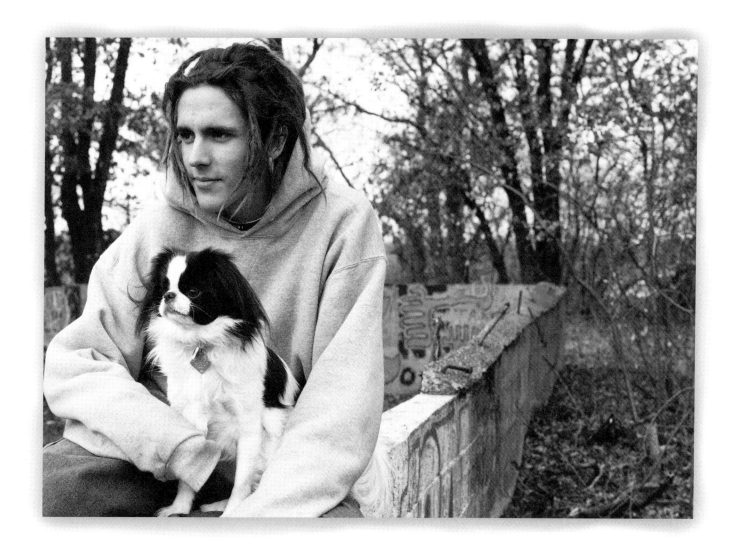

The fidelity of a dog is a precious gift demanding no less binding moral responsibilities than the friendship of a human being. The bond with a true dog is as lasting as the ties of the earth can ever be.

—KONRAD LORENZ

# Frederick Baisch

Magician

40 Years Old

Married

## Selma

Collie/Shepherd

1½ Years Old

Occupation: Therapist/Magician's Assistant

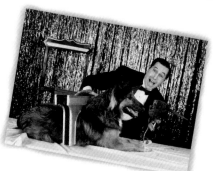

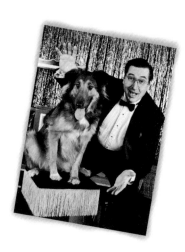

*Selma helps me unwind at the end of a long day, after we do a performance.*

*We unwind by exercising and playing*

*or*

*relaxing affectionately*

*or*

*being silly and laughing.*

*We like to make each other laugh.*

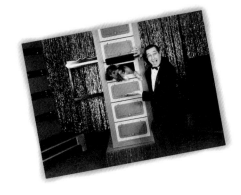

*Selma is sneaky when trying to be a lap dog. Starting with her chin, then one foot, then another,*

*she quietly oozes completely onto me as I lie on my recliner, getting as much of her body resting on me as possible.*

*Selma's my most cooperative subject for new tricks, especially the kind that may include a saw or an explosion.*

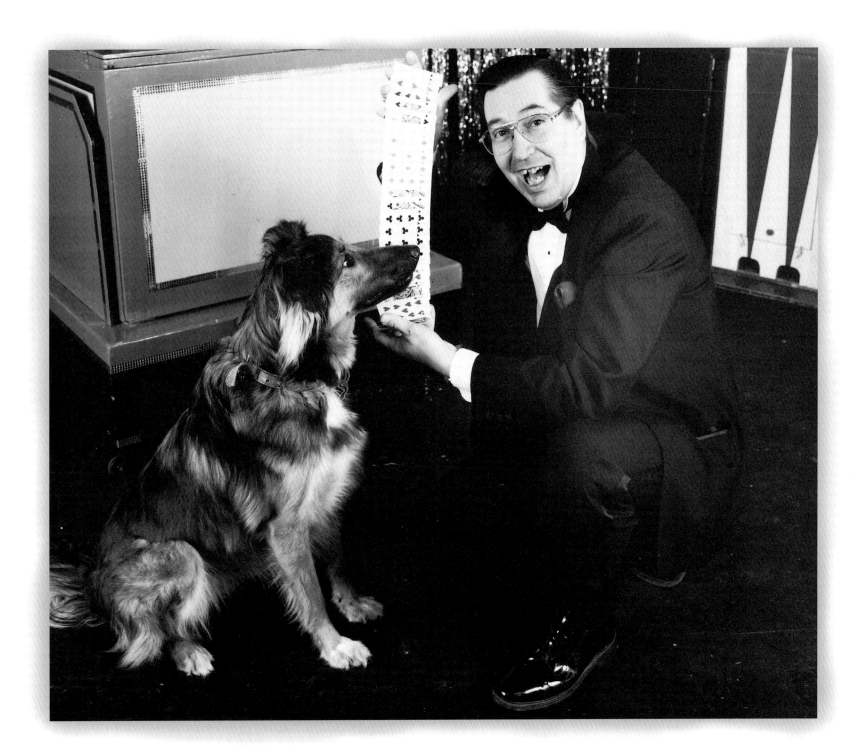

# DAN VALLEJO McGETTIGAN

Owner of Zamas Restaurant & Bungalows in Mexico

48 Years Old

Married

## Stella Luna

Dalmatian/Collie Mix
1 Year Old
Occupation: Groundskeeper,
Beachcomber, Ass Biter

*My family spends half the year in Mexico*

*at Zamas and half the year in San Francisco.*

*In San Francisco, Stella Luna behaves much like any other dog.*

*She eats a lot and hangs around. But in Mexico, she goes to work. Dogs run free in Mexico much like*

*humans do. Stella's job in Mexico parallels mine. I run Zamas for the humans, she takes care of the dogs.*

*Even though Stella helps run the business, she sometimes gets a little spunky and out of hand. She has this habit*

*of ass biting. It's definitely not appropriate behavior to be biting the paying guests in the ass, but it sure is funny*

*to watch. She does this thing where she runs past the person, bites their butt, rams them with her back,*

*pushing them forward, and dashes off. Most people respond with a scream and a jump.*

*It always gets a chuckle from onlookers, and I think that's what encourages*

*Stella to carry on with this nasty habit.*

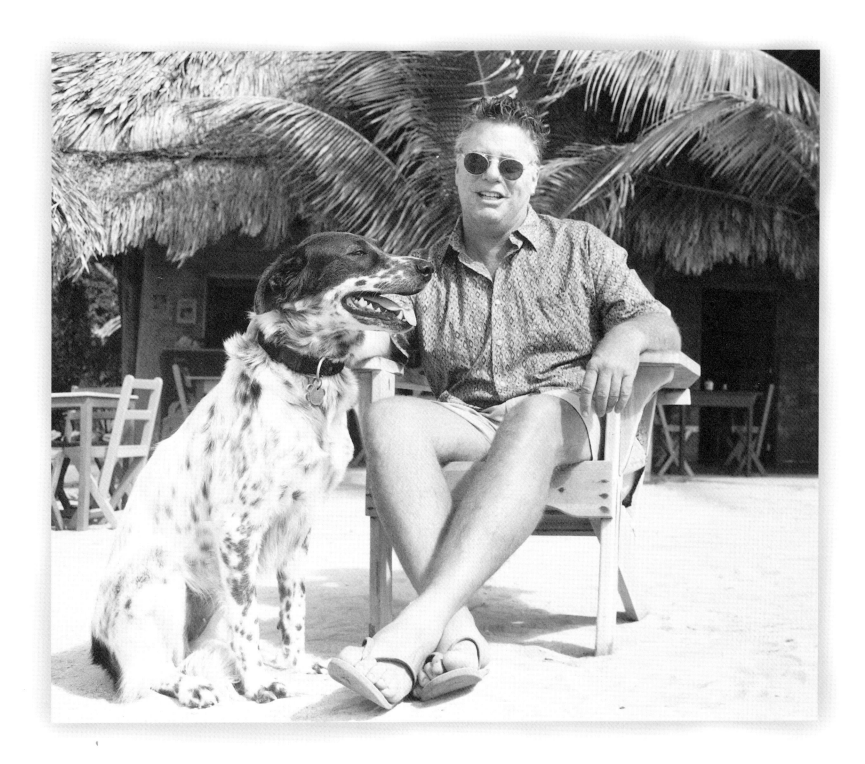

# JAIMISON SLOBODEN

ENGINEER

28 YEARS OLD

MARRIED

Bogart — Saint Bernard
5 Months Old

Barnaby — Saint Bernard
4 Months Old

 *held them when they were no bigger than baked potatoes.*

*My boys have become the center of my life. Everything my
wife and I do revolves around these two Saint Bernards.*

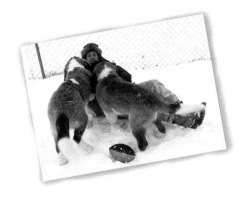

*Bogart remains true to his namesake, Humphrey Bogart.
He's a bit aloof, quite the tough guy, and very much the actor.*

*Barnaby is the cowardly lion from the* Wizard of Oz, *both in looks and demeanor.
He'll bark from a distance but hide behind Mom. His soulful expression shows his soft side.*

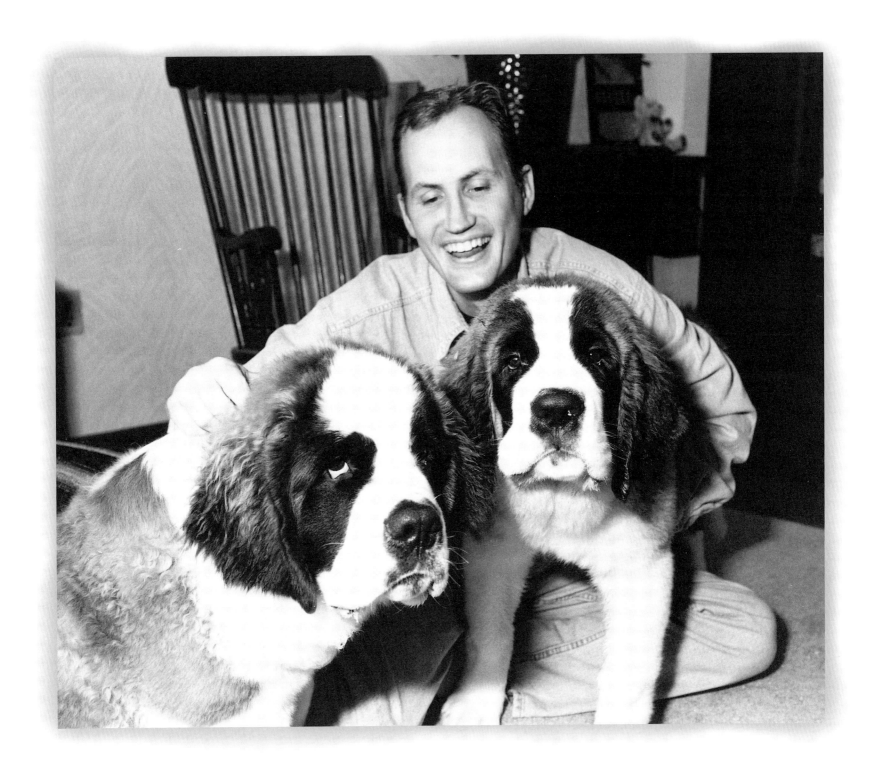

# JOHN BOITMAN

PROJECT MANAGER

48 YEARS OLD

MARRIED

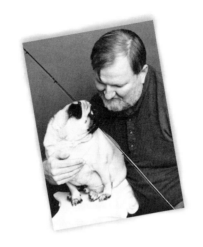

Franco    Pug
1 Year Old
Occupation: Fishing Guide,
Lap Rug, Garbage Disposal,
Snack Hound, Bed Boulder

*For five years I fought the* I want a dog *issue. Then I finally caved in for my daughter's 15th birthday.*

*For a while it was* I want a Chihuahua. *I argued against that and thought sanity had returned:*

*she'd probably pick a Lab or a Brittany or another "manly" dog. The next thing I heard was* Pug.

*A PUG! Who would want a little yipper with a pushed-in face? Reluctantly and under protest,*

*I was engulfed by Pugdom.*

*Franco is my fishing buddy, he runs errands with me in my pickup truck,*

*he's a comedian and a chow hound.*

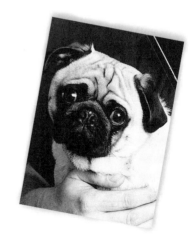

# Multum in parvo—

*A lot of dog in a small space*

# NEIL BRUNNER

CARPENTER/GARLIC FARMER

49 YEARS OLD

MARRIED

## Jett
Chow, etc.
3 Years Old
Occupation: Guard Dog

*Jett is a constant companion. He always announces our visitors. He also "cleans up" about any and all leftovers—he recycles.*

*If Jett were a famous person, he'd be Greg Brown*

> *Bushy*
>
> *Burly*
>
> *Good Ol' Country Boy*
>
> *Loyal*
>
> *Unpretentious*

*We walk at least once a day, about a mile or so. Jett loves to go for rides in the truck.*

*He helps me while I'm working in the workshop by chewing on scraps of wood.*

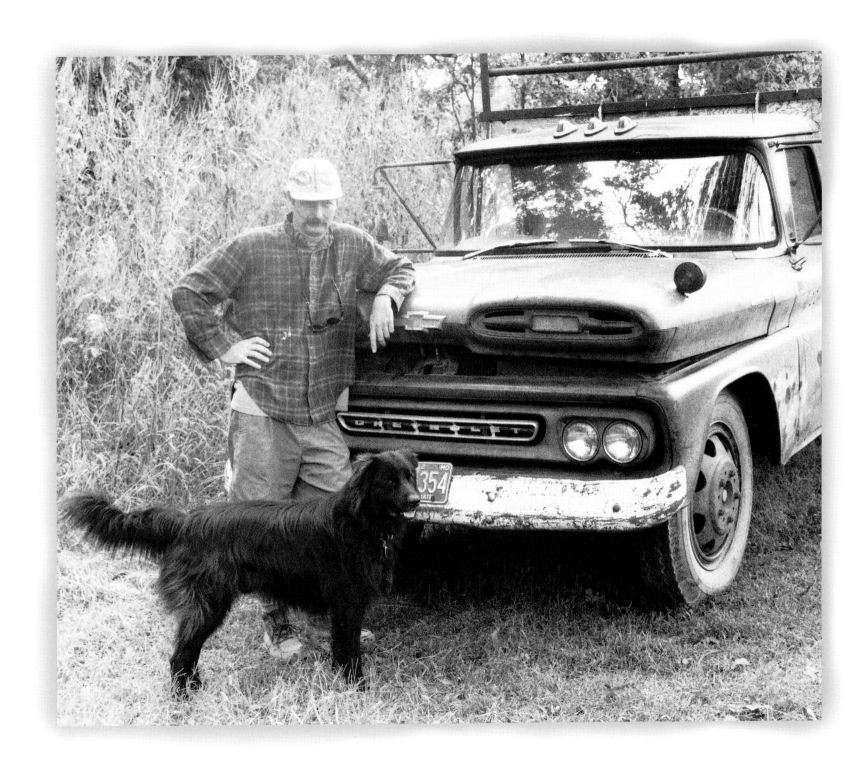

# KEITH UHLIG

NEWSPAPER REPORTER

32 YEARS OLD

MARRIED

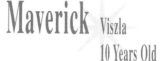

**Maverick** Viszla
10 Years Old
Occupation: Goofball

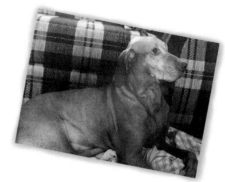

*Maverick has always been a part of things. I've gotten so used to him being around, his face popping up wherever I go, his little cries when he's hungry, cold, or just wanting attention that I can't imagine being without him.*

*When Maverick was younger, he could run like the wind. In close quarters, he's a little clumsy. But when you get him into an open field with a little room, he becomes a work of art, graceful and lithe. Once he nearly caught a rabbit—I never saw a dog run so fast. Maverick has a kind, giving, and fun-loving soul. I don't know many people who have all those qualities in the abundance that Maverick has. I think we all could learn from our dogs.*

*Maverick is my buddy. He is always there when I need him, always willing to cheer me up, and he stands by me no matter how deep my flaws.*

The dog is man's best friend.

He has a tail on one end.

Up in front he has teeth.

And four legs underneath.

—OGDEN NASH

# Jon Oulman

Gallery/Salon Owner

45 Years Old

Single

## Pal

Great Dane
8 Years Old
Occupation: Host

*We are the best at doing nothing. Okay, a little walk, then nothing.*

*My relationship to Pal is one that is unique to man and dog. All understanding and unconditional—*
*he's always happy to see me. He communicates his concern without spoken language—*
*no jealousy or any of the dark aspects of human emotions.*
*Truly an example to love.*

*He's my mentor. He presents himself publicly in the manner*
*best representing his true self.*

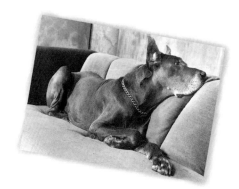

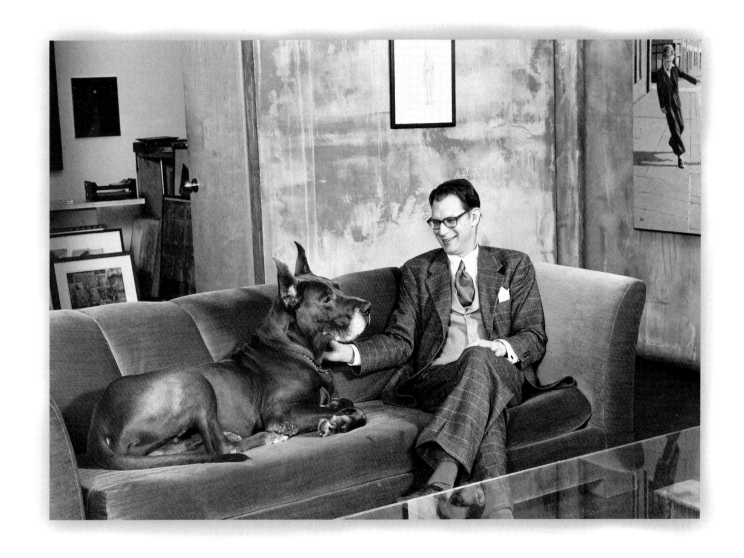

Dogs are our link to paradise. They don't know evil or jealousy or discontent.

To sit with a dog on a hillside on a glorious afternoon is to be back in Eden,

where doing nothing was not boring—it was peace.

—Milan Kundera

# RUSSELL

RETIRED

SINGLE

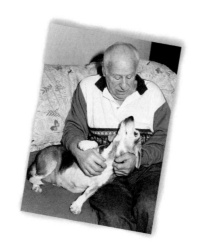

Velvet — Beagle
12 Years Old
Occupation: Nuisance Dog

Spuds — Springer Mix
7 Years Old
Occupation: Retired

*Velvet is a nuisance. If I leave her, she takes off.*

*We went to Al Capone's hideout in Wisconsin. Velvet took off.*

*She doesn't harm anyone but takes off all over the neighborhood.*

*Velvet is a great companion because I am totally alone. Even if I yell at her,*

*she comes right back with affection. I guess that's what dogs do—*

*that's their nature. My dogs are my family—*

*they're all I have.*

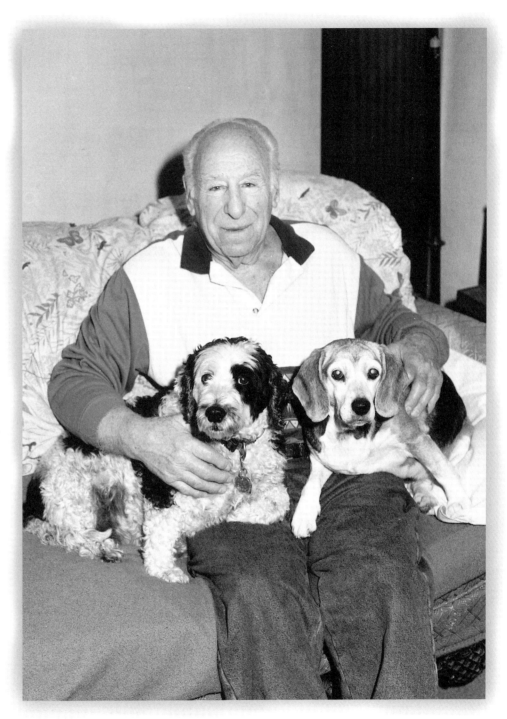

**B**uy a pup and

　　your money will buy

Love unflinching

　　that cannot die.

　　　　　　—RUDYARD KIPLING

# Chuck Phillips

Karate Instructor

Married

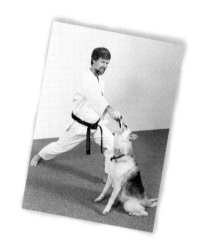

**Courtney**
German Shepherd/Siberian Husky
9 Years Old
Occupation: Top Dog

**Sheila**
German Shepherd/Pit Bull Terrier
8 Years Old
Occupation: Baby/Second Fiddle

**Kensington**
*(aka Kensie)*
American Eskimo/Poodle
9 Years Old
Occupation: Man of the House

**Leda**
Pit Bull Terrier Mix
4 Years Old
Couch potato/Living Room Decorator

*Courtney was our first dog as a family. The other dogs are all foster dogs who decided to stay with us for a variety of reasons. Kensie was our first foster dog and had dryer lint for brains, so we thought no one else would adopt him. Sheila was our next adoption. She followed Courtney everywhere, competing for attention. Leda, our youngest, is very much like A. A. Milne's Eeyore. Once she found us she was just too comfortable to be bothered to look elsewhere. It is a wonderful magic they perform at the end of a stressful day when I lie on the floor and pet and play with them. They give us love without questions. And each of them will take a noogie and come back for more.*

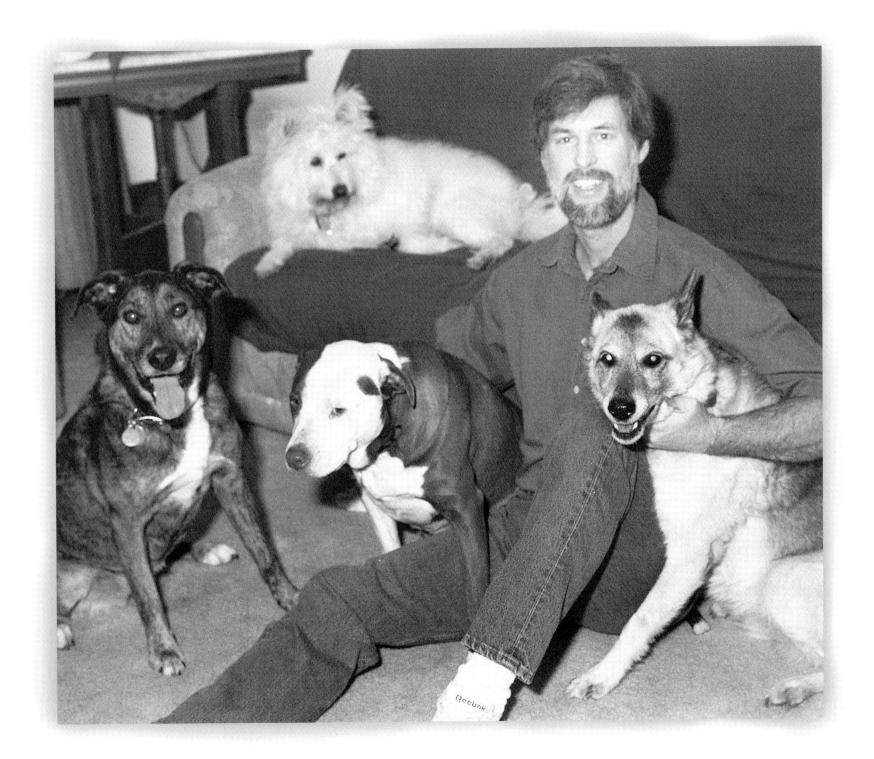

# EAMON RICE (AKA EAMON MCSHANE)

STAND-UP COMEDIAN

35 YEARS OLD

MARRIED

### Mocha
Lab/Weimaraner
22 Months Old
Occupation: Ball Freak

*I enjoy taking care of Mocha. She runs with me when I run or Rollerblade. She is also a great peacemaker because she hates it when my wife and I fight.*

*Mocha's favorite game is bringing the ball to me when I'm in the tub. This has been her favorite game—and mine as well—since she was tall enough to reach.*

*I was thinking about the horrible prospect of Mocha being lost or stolen, so I checked out my options. I found out that I could either have her tattooed or microchipped. Even though microchipping a dog is expensive, I chose that over tattooing. I just didn't feel right about taking Mocha to the wrong side of town and getting her drunk first.*

*Mocha has taught me patience, selflessness, and responsibility. She is my baby, my best friend…
It almost scares me how much I love that dog.*

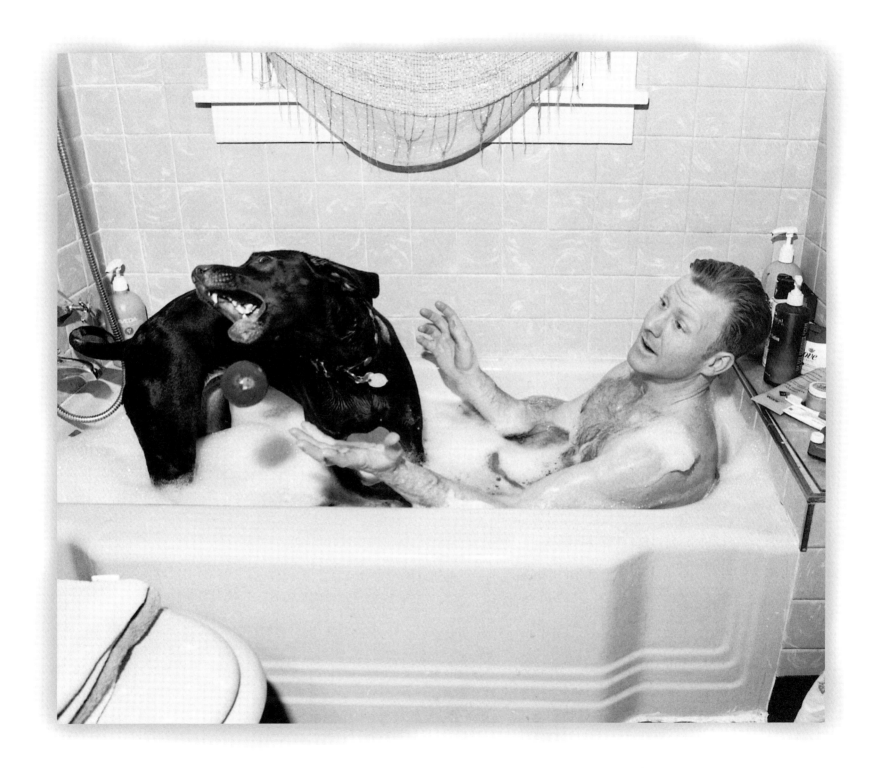

# ROB WOOD

COMPUTER CONSULTANT

35 YEARS OLD

MARRIED

## Sandy

Golden Retriever

3 Months Old

Occupation: Eating, sleeping, playing, providing comic relief, loving and being loved. With so many responsibilities, it's a full-time job.

*Sandy is my friend and companion. He is warm and furry and no matter how good or bad things are in my life, he loves me just the same. He is stabilizing and comforting. He does not have exceedingly high expectations of me.*

*Sandy is always a constant in my life—no matter what is going on. He is like a child with fur who needs my guidance and protection. Yet when I talk to him, he appears to listen with great maturity and wisdom. And he never judges me. He makes me see the lighter side of things—he makes me laugh.*

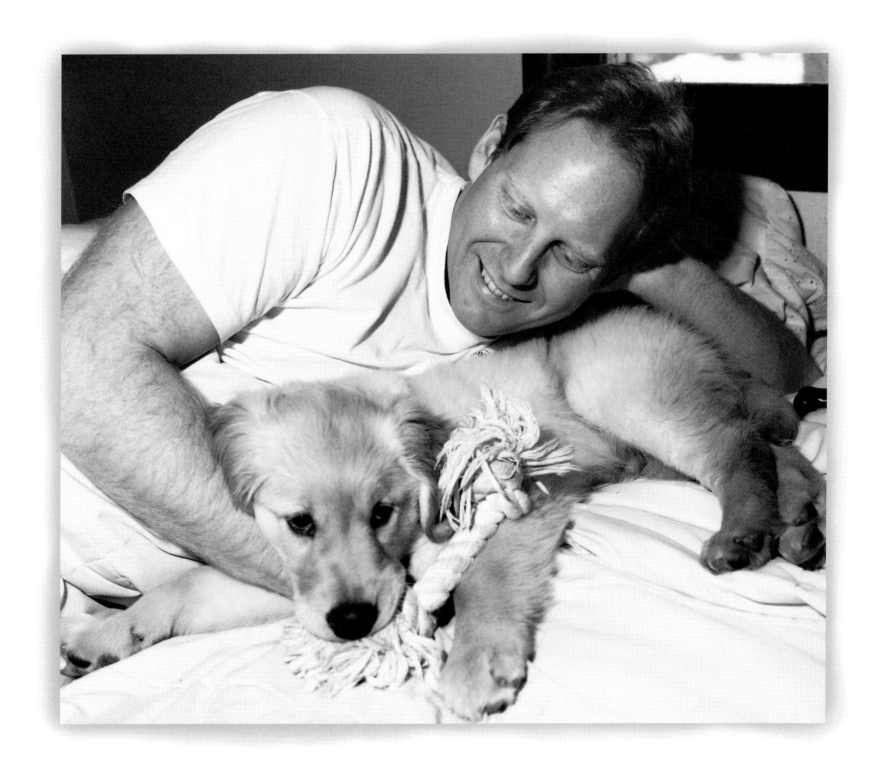

# ROB ANDERSON

ROOFER

27 YEARS OLD

MARRIED

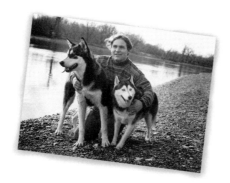

Chica    Siberian Husky
7 Years Old

Samson    Alaskan Malamute
1 Year Old

*I sometimes wonder what Chica and Samson must dream about. I have to think their perfect day would be running free, chasing rabbits, squirrels, and deer on their way to an all-you-can-eat buffet where dogs are allowed, and then taking a nap on fresh powder snow.*

*Chica and Samson require a lot of exercise. They help keep me from getting caught up in the fast-paced modern rush. Taking them for a walk first thing in the morning helps me ease into the day and lets me meditate and find my balance for the day. Exercising my dogs keeps me from focusing on myself and lets me enjoy their happiness. The sight of those two born-running dogs chasing each other free down by the Mississippi River is great. They treat depression better than any happy pill!*

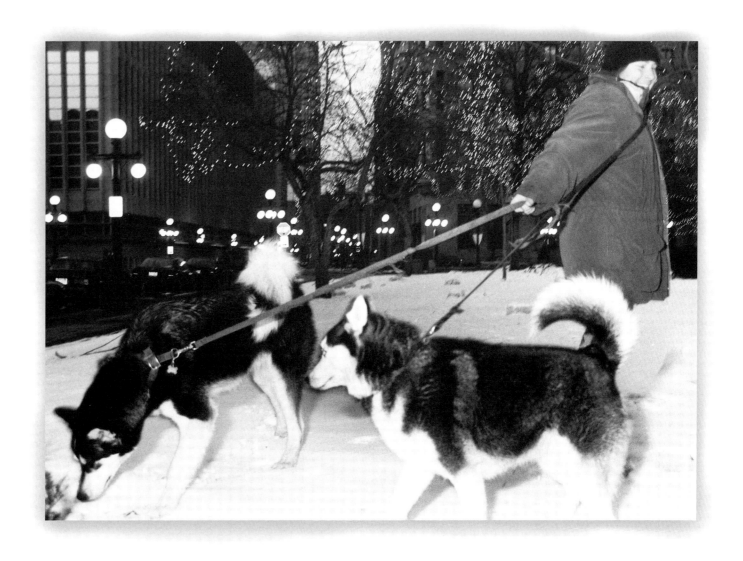

All knowledge, the totality of all questions
and all answers is contained in the dog.

—Franz Kafka

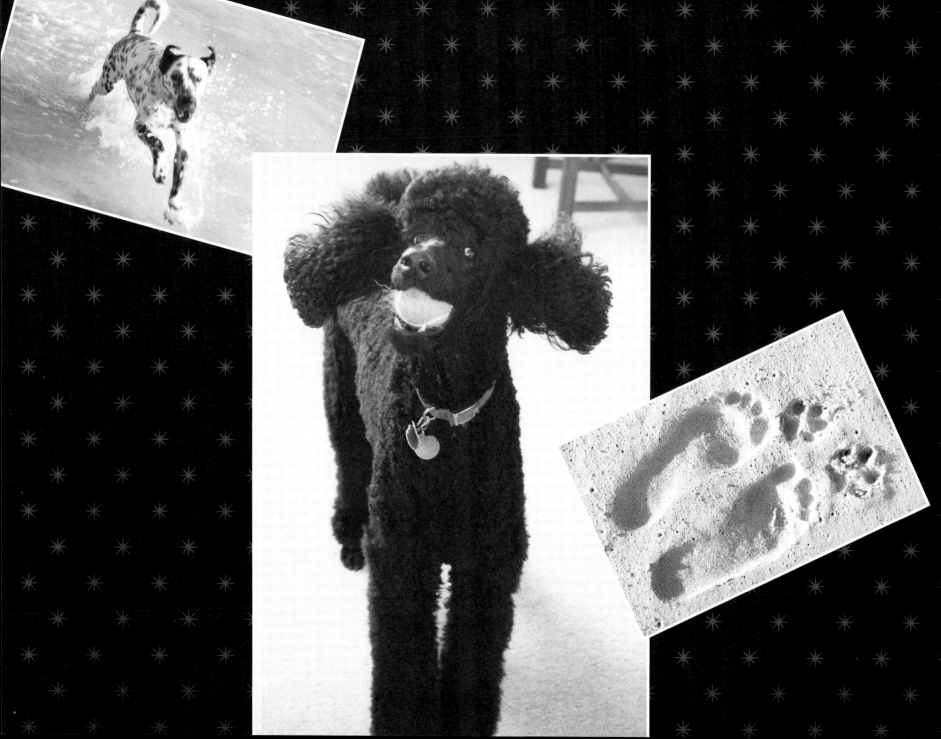

# JOHN SOKALSKI

CHEMICAL ENGINEER

238 YEARS OLD (IN DOG YEARS)

HAPPILY MARRIED

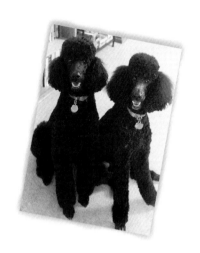

**Teddy**

Standard Poodle
3 Years Old (in people years)
Occupation: Certified Therapy Dog

**Tyler**

Standard Poodle
4 Years Old (in people years)
Occupation: A Handful

*On bad days, the dogs are the drain on my time and the little children who will never grow up and who have to be watched constantly. On the good days, there is nothing like playing chase with poodles, getting "puppy kisses," or just watching the antics of my "boys" as they play with each other. Their lives and routine are so woven into mine that I can't imagine being without them.*

*In the winter months, nothing is quite as comfy as stretching out in the recliner with a warm poodle pulled up on your belly.*

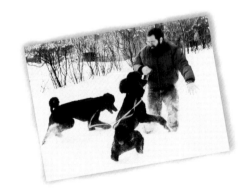

*My dogs are my children, plain and simple. A friend once told me, "You feed them. You clean up after them. You take them to the doctor. They have school. They have sports. Face it, you've got a couple of funny-looking kids." I wouldn't trade them for the world.*

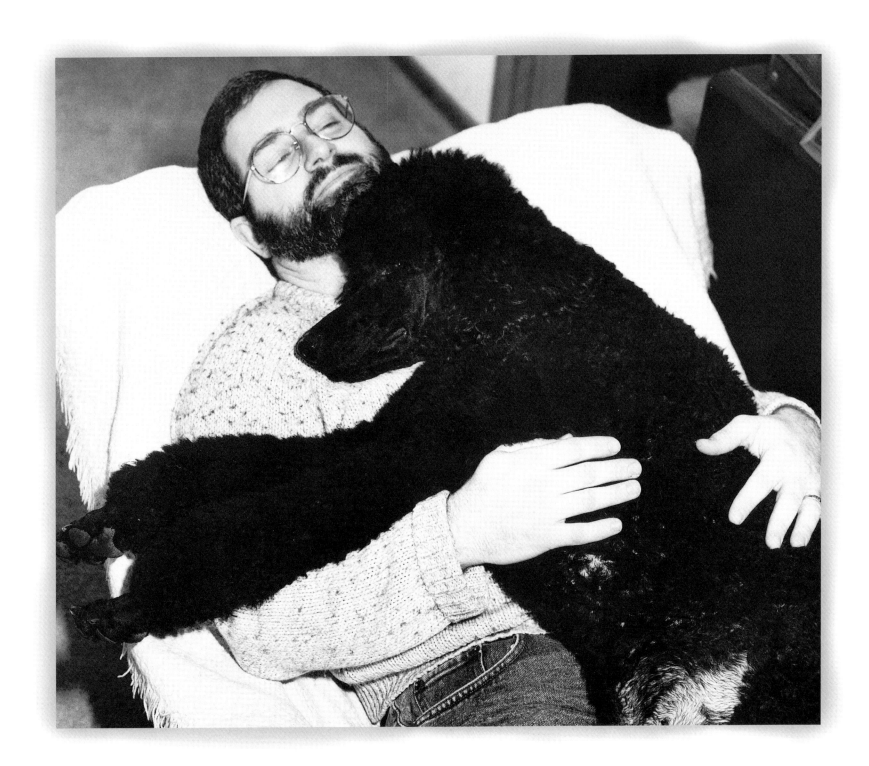

# TOM BLANCK

ARCHITECT

53 YEARS OLD

MARRIED

# Wookey

Bichon Frise

6 Years Old

Occupation: Architect-in-Training

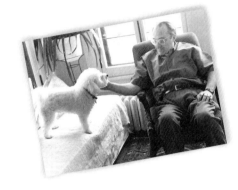

*Wookey is a loving companion who is with me while I work in my one-person office. He sees to it that I am organized and that I take frequent breaks from my work. We have long discussions about what to do next. He is an excellent doorman and does a good job of leading us on walks.*

*Wookey is my best friend after my lovely wife, Linda, who is happy that Wookey sops up so much of my time and attention, yielding Linda more personal free time.*

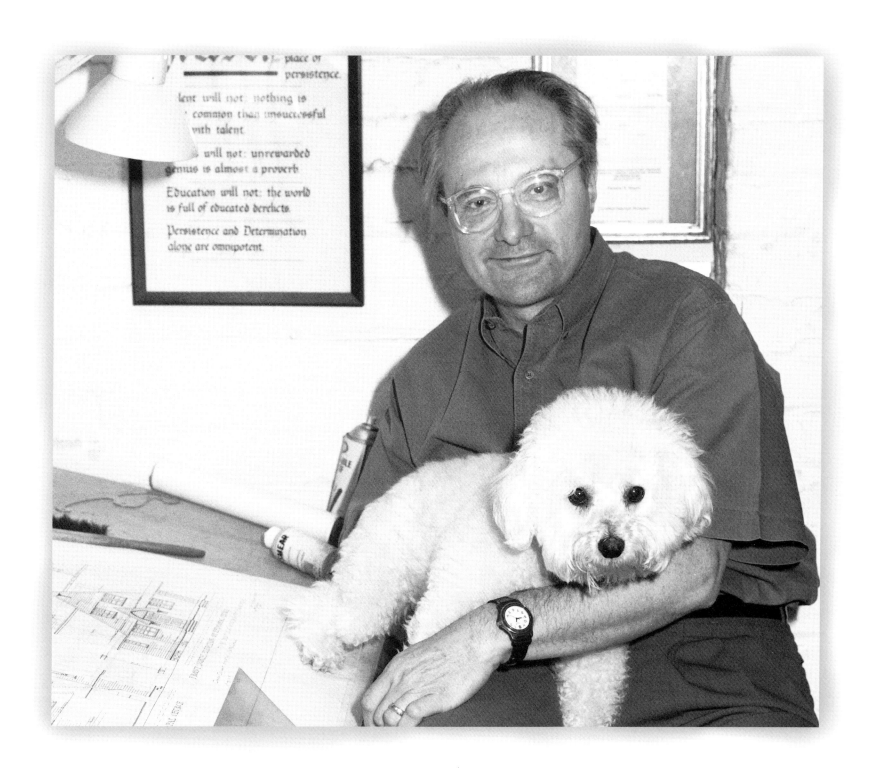

Nothing in the world can take the place of persistence.

Talent will not: nothing is more common than unsuccessful men with talent.

Genius will not: unrewarded genius is almost a proverb.

Education will not: the world is full of educated derelicts.

Persistence and Determination alone are omnipotent.

# KENE MAXIE

PAINTER

35 YEARS OLD

MARRIED/GAY

## Sprocket
Basenji
4 Years Old

## Reina
Basenji
1 Year Old

Occupation: House Sitters

*When I got the dogs, all I thought of was the fun we would have together. Now I find myself running home to feed the dogs and planning weekends around them. No matter how I feel, Sprocket and Reina have to be cared for. But this is a labor of love.*

*The best thing about these dogs is that they easily adapt to my moods. Whether I want to venture outside or just lounge around, they are willing and ready to do both.*

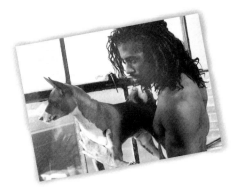

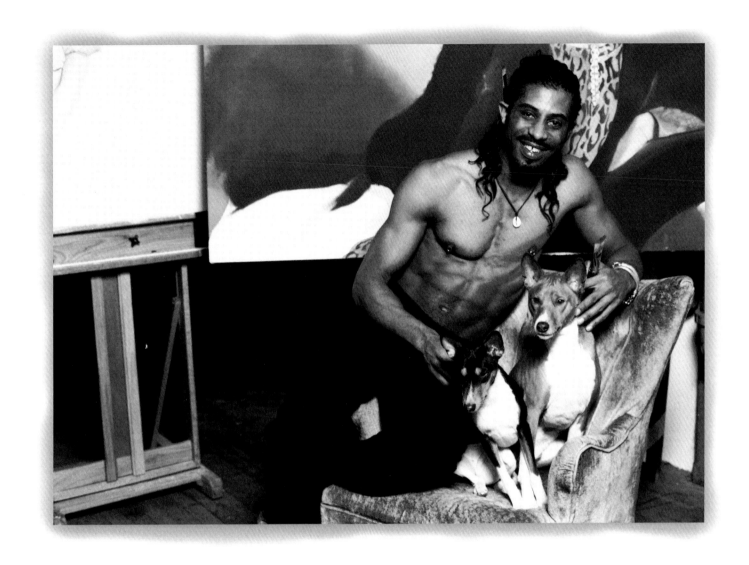

No man can be condemned for owning a dog. As long as he has a dog,

he has a friend; and the poorer he gets, the better friend he has.

—WILL ROGERS

# TONY HEDBERG

BARTENDER/STUDENT

32 YEARS OLD

SINGLE

Greta — Shepherd/Husky Mix
4½ Years Old

Jack — Swiss Mountain Dog/Lab Mix
1 Year Old

Occupation: Professional Squirrel Hunters

Every morning when I wake up my dogs are there.
They love to sit on the bed and have me pet them.
They're very competitive about who gets more attention.
It's a wonderful feeling to have two very affectionate dogs.

Greta and Jack have great sarcastic personalities and they're
a real joy to be around. They are guy dogs because of their
athleticism and because we just like hanging out.

Dog. A kind of additional or subsidiary Deity designed to catch the overflow and surplus of the world's worship.

—AMBROSE BIERCE

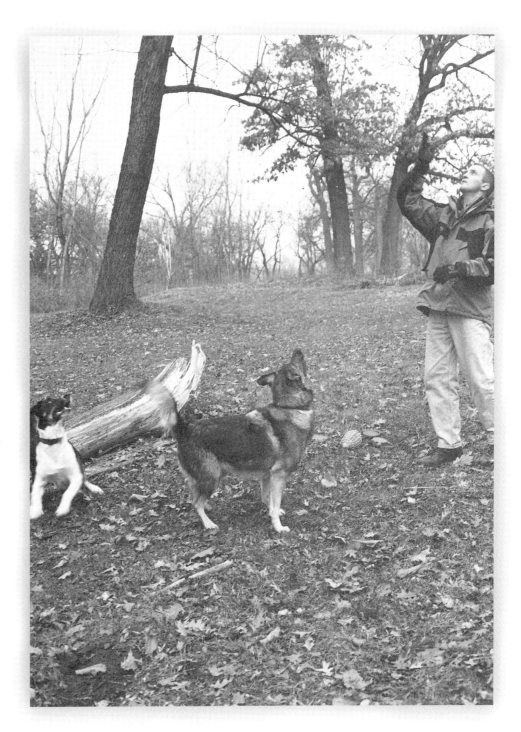

# HENRY GOMEZ

DESIGNER

42 YEARS OLD

MARRIED

## Helmet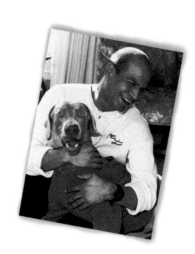

Weimaraner

2 Years Old

Occupation: Currently Unemployed

*When we are in the car going hunting and I fire off a shot, Helmet goes totally crazy. He wants to get out of the car and look for the bird.*

*Helmet acts like me when we're outdoors. He loves it!*

*I'm learning patience from Helmet.*

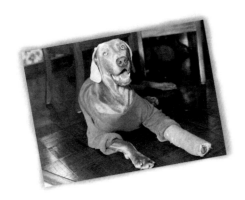

$M$an is troubled by what might be called the Dog Wish, a strange and involved compulsion to be happy and carefree as a dog.

—JAMES THURBER

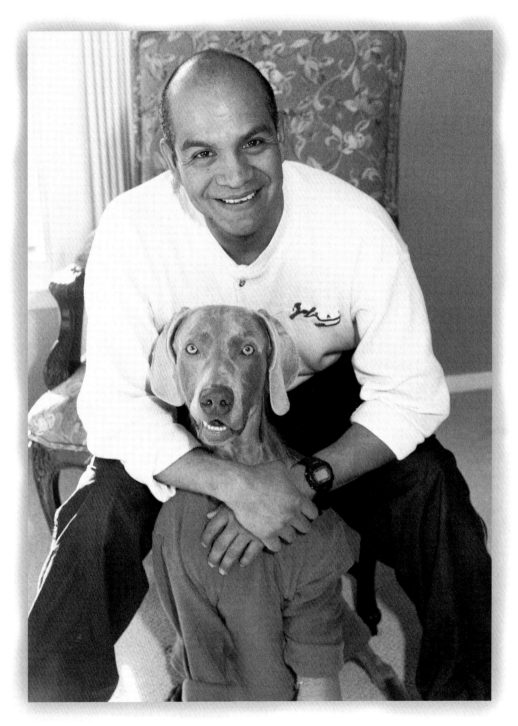

# CARLOS J. CHAVÉZ

CLOTHING DESIGNER

41 YEARS OLD

SINGLE

Oso

Blue Chow Chow
9 Years Old
Occupation: Mascot/Guard Dog

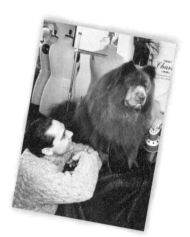

*What I admire most is the smile that comes across people's faces*

*when they see Oso in my downtown custom clothing store. For a split*

*second, these people forget about all their troubles and smile at my dog.*

*You have no idea what a pet can do to your life—he changes your life forever!*

*With Oso, I've learned about unconditional love. My dog is my best friend.*

*We go everywhere together—to the bank, store. We even go buy beer together—they love him there.*

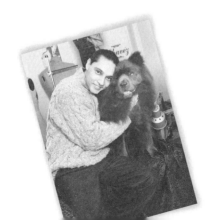

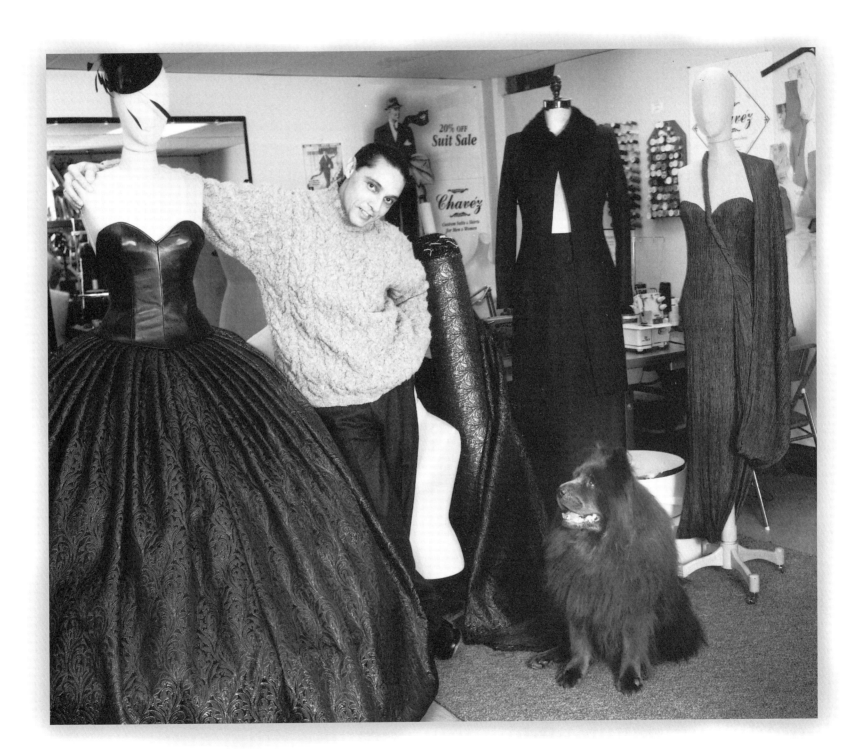

# TED BELL

OWNER/FOUNDER OF BELL CANOE WORKS

45 YEARS OLD

MARRIED

## Maggie

Golden Retriever
10 Years Old
Occupation: Canoeing Scout

*Maggie is an expert canoer. She knows exactly how to board, ride, and scout as we move along streams, rivers, and lakes.*

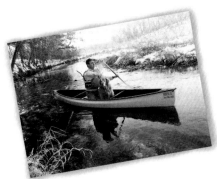

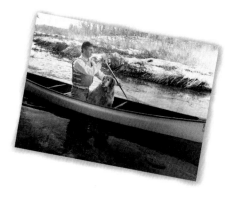

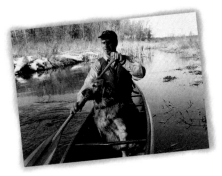

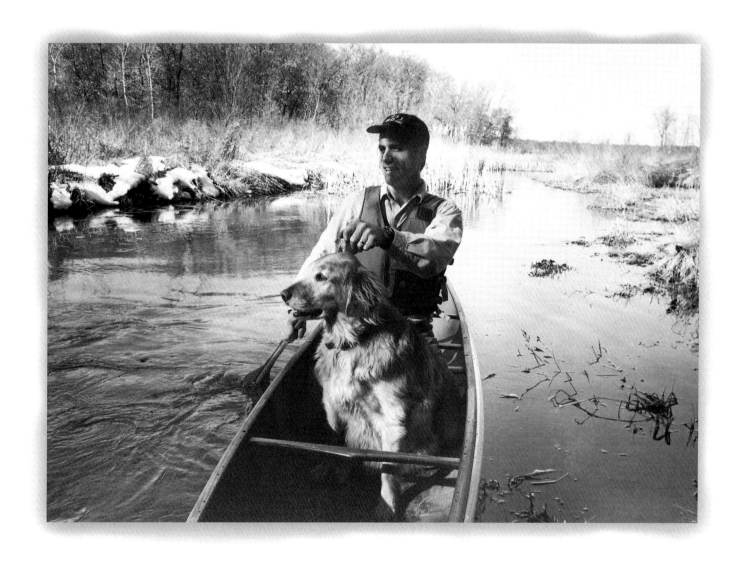

$\mathbf{H}$e seemed neither old nor young. His strength lay in his eyes. They looked as old as the hills, and as young and as wild. I never tired looking into them.

—JOHN MUIR "AN ADVENTURE WITH A DOG"

# CARLOS CEBALLOS Y CEBALLOS

### HOTEL MANAGER AND MUSICIAN

### PLAYA DEL CARMEN, MEXICO

### 50 YEARS OLD

### SINGLE

## Tanga
Lab Mix
4 Months Old

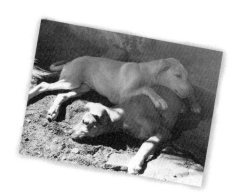

## Panishike
Lab Mix
4 Months Old

Occupation: Guard Dogs

*Tanga and Panishike are the*

*grandchildren of my beloved Lab mix who died.*

*They are being trained to be guard dogs for the hotel* Posada Chuna an Bakte.

*But mostly they lick the customers and play. They play, play, play, then they get tired and sleep, over and over again.*

*Tanga means "small sexy bikini." Tanga is the wilder of the two, and when she walks, her butt from behind looks like a woman's with a bikini that's too small.*

*Tanga and Panishike siesta in the hammock with me every day, and they come in my room at night. But they run around the grounds of the hotel all day. They know to stay on the ground level, but sometimes they sneak around upstairs.*

*Panishike means "funny guy." He's my favorite because he's more dedicated and listens better. They both bring me a lot of joy and provide entertainment all day long while waiting for guests to arrive—much better than TV.*

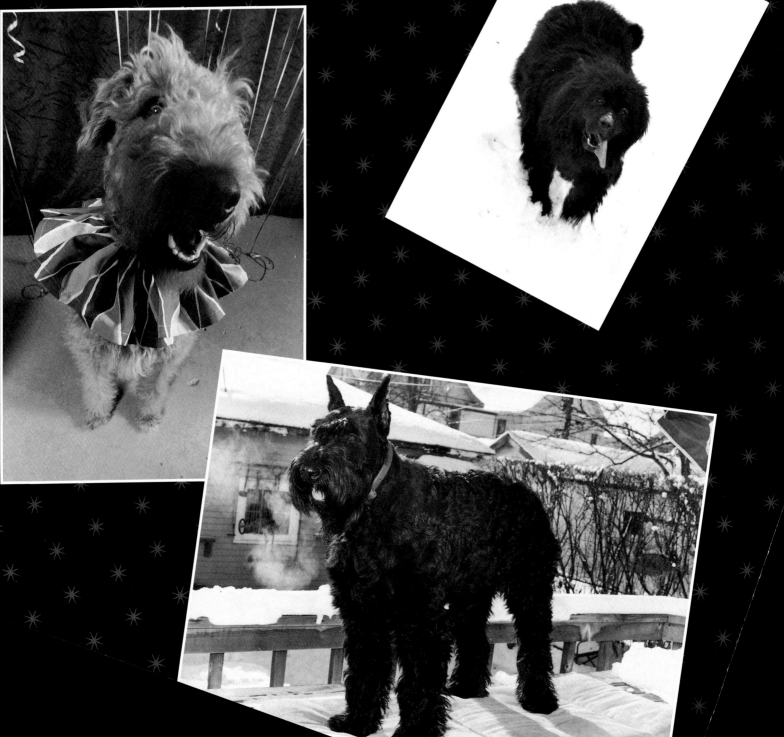

# GARY L. IVERSON

CERTIFIED PUBLIC ACCOUNTANT/TRAVELER AND COLLECTOR

52 YEARS OLD

MARRIED

## Caralon Bwana
*"Duma"*

German Shepherd Dog
Male—Mostly Black
9 Months Old
Occupation: Troublemaker, Dickens

## New Skete's Beda
*"Zika,"* CGC, TD, TDX

German Shepherd Dog
Female—Black & Tan
4 Years 10 Months Old
Occupation: Tracker

*My Dogs are my sidekicks.*

*My wife and I take them with us*

*as often as we can. They function as*

*alarm clocks and wake us each morning*

*with wet kisses. They both sleep in bed with us. Though it's a king-size bed, there isn't much room.*

*Right now my wife is angry with Duma and me. She went to Kenya and brought home*

*two sets of goat bells made from sheep testicles. Yesterday Duma ate them.*

*Boys will be boys.*

*My dogs have a calming, homey affect on me, and I can completely relax*

*with them at my side.*

# DAVID P. BURTNICK

SELF-EMPLOYED CARPENTER/ELECTRICIAN

50 YEARS OLD

SINGLE

## Narnian Nara
Giant Schnauzer
2 Years Old
Occupation: Companion

*Nara was on a horse ranch near Stillwater, Minnesota.*

*She was in trouble with neighbors for chasing deer and running wild.*

*Through a friend, I claimed her. She came with fifty ticks.*

*At work and at home, Nara is my friend, companion, and guardian.*

*I am proud of her handsome conformation and the way I tend to her needs.*

*Watching Nara run is like poetry.*

*Pride can be a powerful thing. I'm proud of my dog.*

*The way she looks, acts, and her agility. She is a guy dog*

*because guys need to stay in touch with their wild nature.*

# SATOSHI SHINOZAKI

SOFTWARE ENGINEER

38 YEARS OLD

SINGLE

Kato — Yorkshire Terrier/Pomeranian/Mini-Poo/Shih Tzu
10 Months Old
Occupation: Entertainer/Lounge Act

 was sitting at my computer one evening when the maintenance man approached me with an object in his hands. He said, "Hey Satoshi, look what I found in recycling." Larry was holding a 1½-pound puppy who barely filled up his palm. I immediately snatched him up and claimed him for my own. He slept in my lap for the last two hours of work and has been with me ever since.

I like to take Kato to the dog park so he can beat up on the big dogs. Kato has a little-dog complex— he refuses to accept his size as a limitation.

Kato is so compact I can put him in my shirt when I go Rollerblading, to the video store, even to a coffee shop. He is a great listener, entertainer, and he never talks back. He loves to sleep donut-style in the contour of my belly.

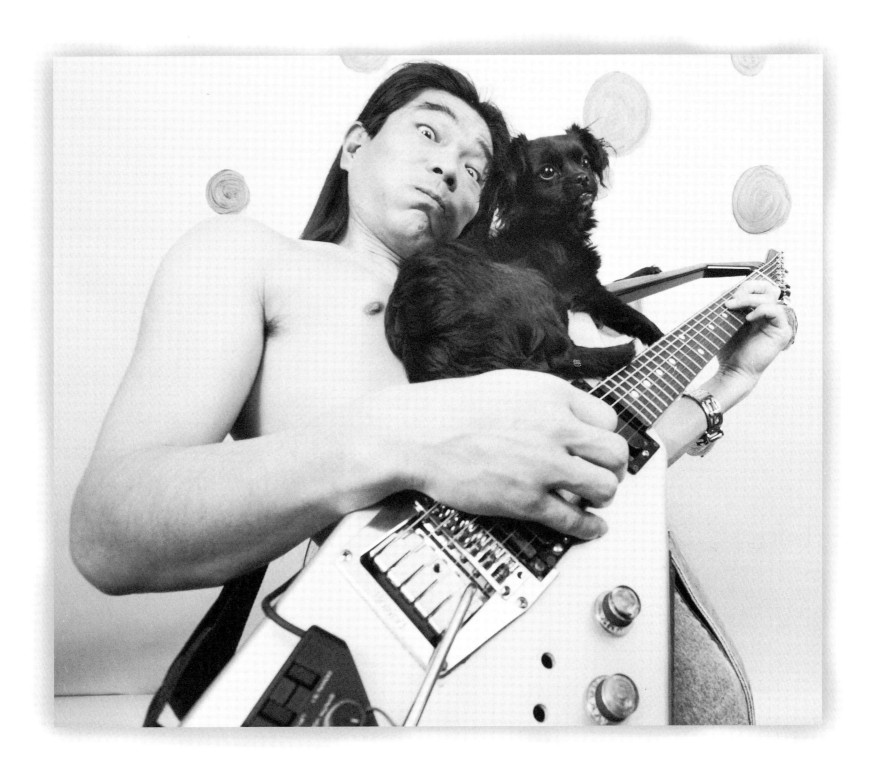

# TOM BURNEY

COMPUTER GRAPHICS ARTIST

34 YEARS OLD

SINGLE

## Whoopi
Newfoundland
9 Years Old
Occupation: Lounge Act

*Newfies are supposed to be great swimmers,*

*but Whoopi is terribly afraid of the water.*

*I've tried to get her used to swimming by wading*

*out with her, but as soon as her paws are no longer touching*

*bottom, she starts whining and coughing. It's rather embarrassing.*

*Whoopi prefers to stand knee-deep in water by the shoreline and look majestic.*

*Whoopi is a perfect example of unconditional love. There isn't a hostile bone in her body.*

*When I'm happy, she's happy. When I'm upset, she's happy. She always cheers me up.*

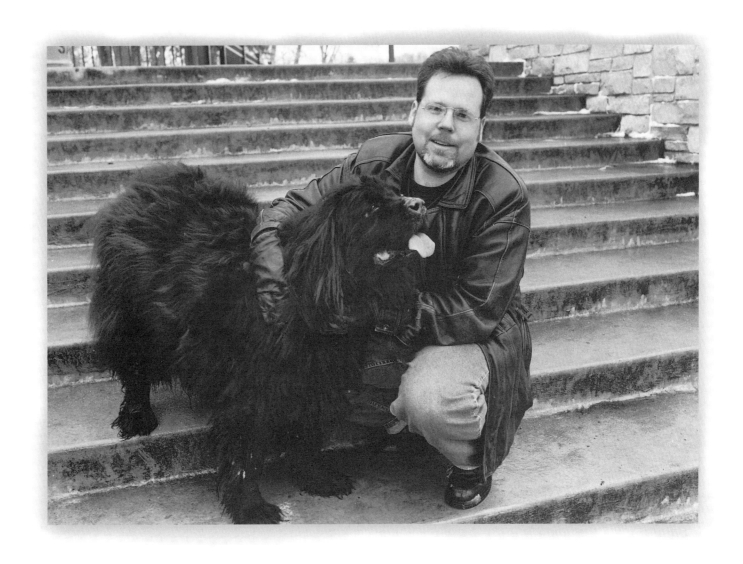

Qui me amat, amet et canem meum.

*(Love me, love my dog.)*

—Saint Bernard, 1150 a.d.

# OZZIE

CLOWN

40 YEARS OLD

MARRIED

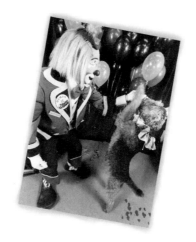

Bailey and I take long naps together in my recliner.

She also likes to play "catch me if you can" around the dining room

table, usually with one of my hats or my wig in her mouth.

When Bailey was 10 weeks old, I called to her to come in from the yard.

She just sat in the middle of the lawn and looked at me then at the ground in front of her.

She wanted me to come to her. When I went out to see what was wrong, I found a helpless baby bird there.

I think Bailey was concerned. (Of course, the next baby bird she found she ate.)

Our favorite acts are the ones kids love so much they have a tough time breathing in

between laughter. Just Bailey's presence in her funny clown collar and hat gets them roaring.

## Bailey

Airedale Terrier

1 Year Old

Occupation: Junk Mail Shredder/Clown Dog

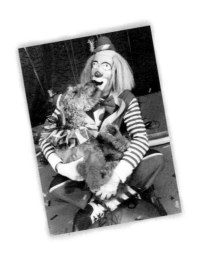

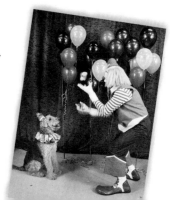

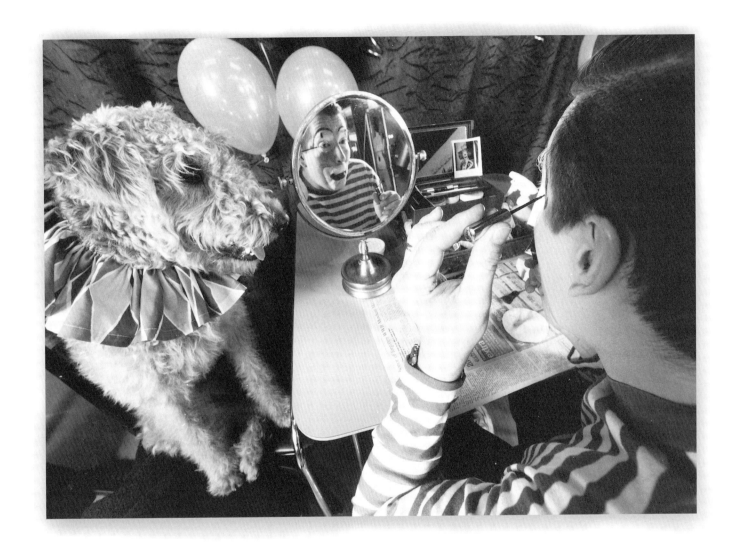

Children and dogs are as necessary to the welfare

of the country as Wall Street and the railroads.

—HARRY S. TRUMAN

# JEFF AUSTIN

BUSINESS OWNER/WORLD TRAVELER

39 YEARS OLD

SINGLE

## Mol-i

Afghan Hound
7½ Years Old
Occupation: Dust Mop

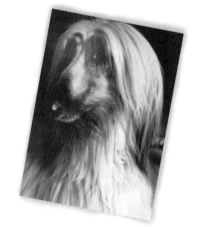

*We met at an art gallery opening.*

*Mol-i is the most honest and faithful female in my life.*

*While riding in the car, Mol-i sits proudly in the passenger seat, wearing a seatbelt. She has been mistaken several times for an attractive blonde until she turns her head to show her long black nose!*

*Mol-i has provided me with warmth and comfort by being a faithful companion.*

The great pleasure of a dog is that you may make a fool of yourself with him and not only will he not scold you, but he will make a fool of himself too.

—SAMUEL BUTLER

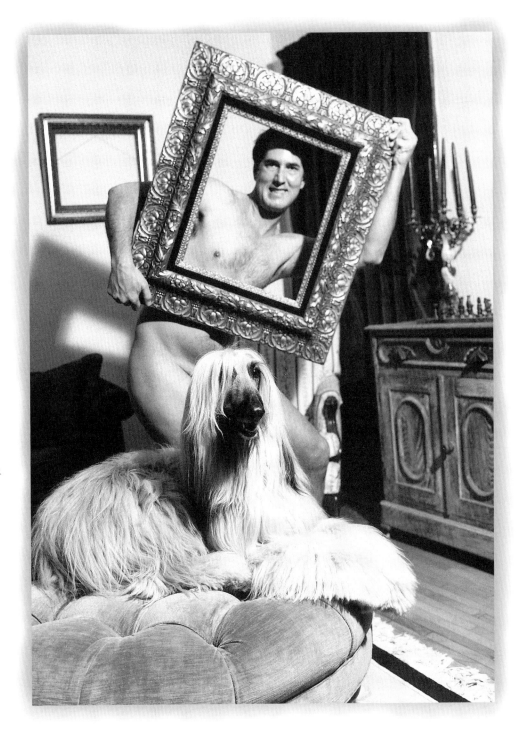

# DAN ANDERSON

VETERINARIAN

34 YEARS OLD

SINGLE

Hazel  Chihuahua
2 Years Old

Maybelline  Basset Hound
7 Years Old

Occupation: Companions

My dogs are central in my life.
They keep me active, get me up and
moving at times when probably I wouldn't.
They have a way of lifting my spirits when I'm down.

Maybelline goes fishing with me. She loves to go in the boat
and she loves to swim. But she's scared of the fish.

My dogs are definitely my friends and in many ways they are like children to me.

I think my dogs, and dogs in general, give much more than we can ever know. They are examples of
absolute loyalty and unconditional love. As a guy, I think I need to be reminded that those things exist.

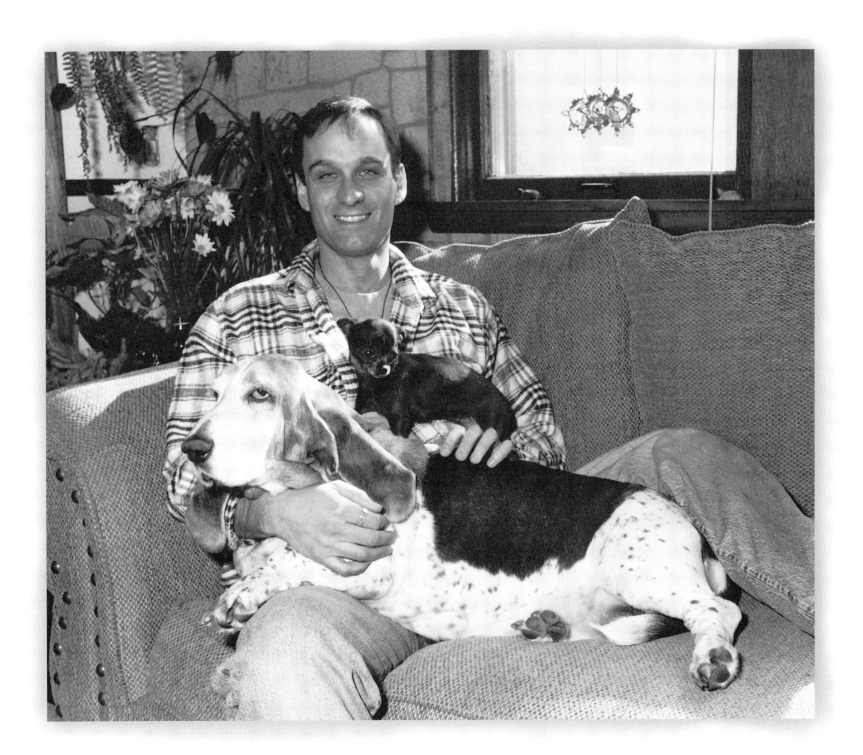

# JOEL SHEAGREN

PHOTOGRAPHER

42 YEARS OLD

MARRIED

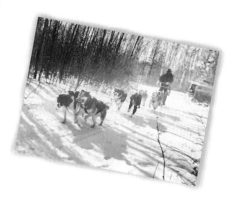

*I have pets by day, sled dogs by night. My dogs are family members, race buddies, camping buddies, running buddies, and swimming buddies.*

*Weekly during the winter my dogs and I head out to have an adventure. Their excitement to pull is contagious. We have had moose and deer run on the trail in front of us during training. We have traveled in temperatures of −45° F with strong winds pushing at our faces. We have seen countless moons and have heard the silence of the woods more hours than anyone can count. Our life together is filled with adventure and the warmth of memories that will last a lifetime.*

Smokie,
Gib,        Husky Mixes
Ariel

Viking,
Banff,        Alaskan Huskies
Drummy

Occupation: Sled Dogs

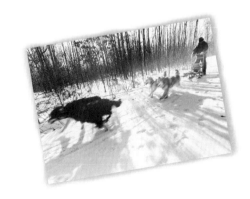

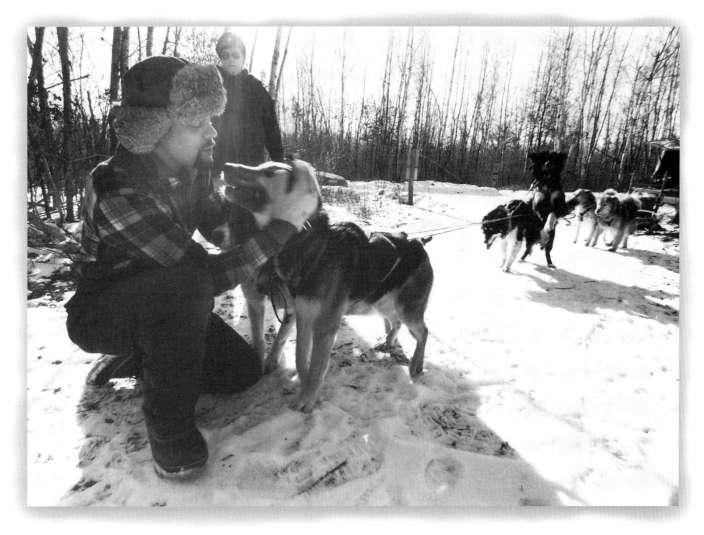

Upon the snow we dance

Fast, quietly we move

Barren trees pass like the rhythm of a song

We are dancing, they and I upon the snow

—JOEL SHEAGREN

**W**hen the Man waked up

he said,

"What is Wild Dog doing here?"

And the Woman said,

"His name is not Wild Dog

any more,

but the First Friend,

because he will be our friend

for always and always and always.

—RUDYARD KIPLING

*Place Your Picture Here.*

# About the Photography

THE PORTRAITS IN *GUYS & DOGS* were shot full frame, primarily with a Mamiya 645 medium format camera and TMAX 100 film. Photographer Laurie Schneider changed her approach based on each guy-dog couple. She took candid pictures of some of the couples, while others were posed portraits. Laurie drew her subjects from a variety of sources: a few she knew before starting the project, others she was referred to, and she was drawn to some of the guy-dog couples and decided to approach them on her own. While working on this project, Laurie met some really interesting people and a few dogs she wanted to take home with her.